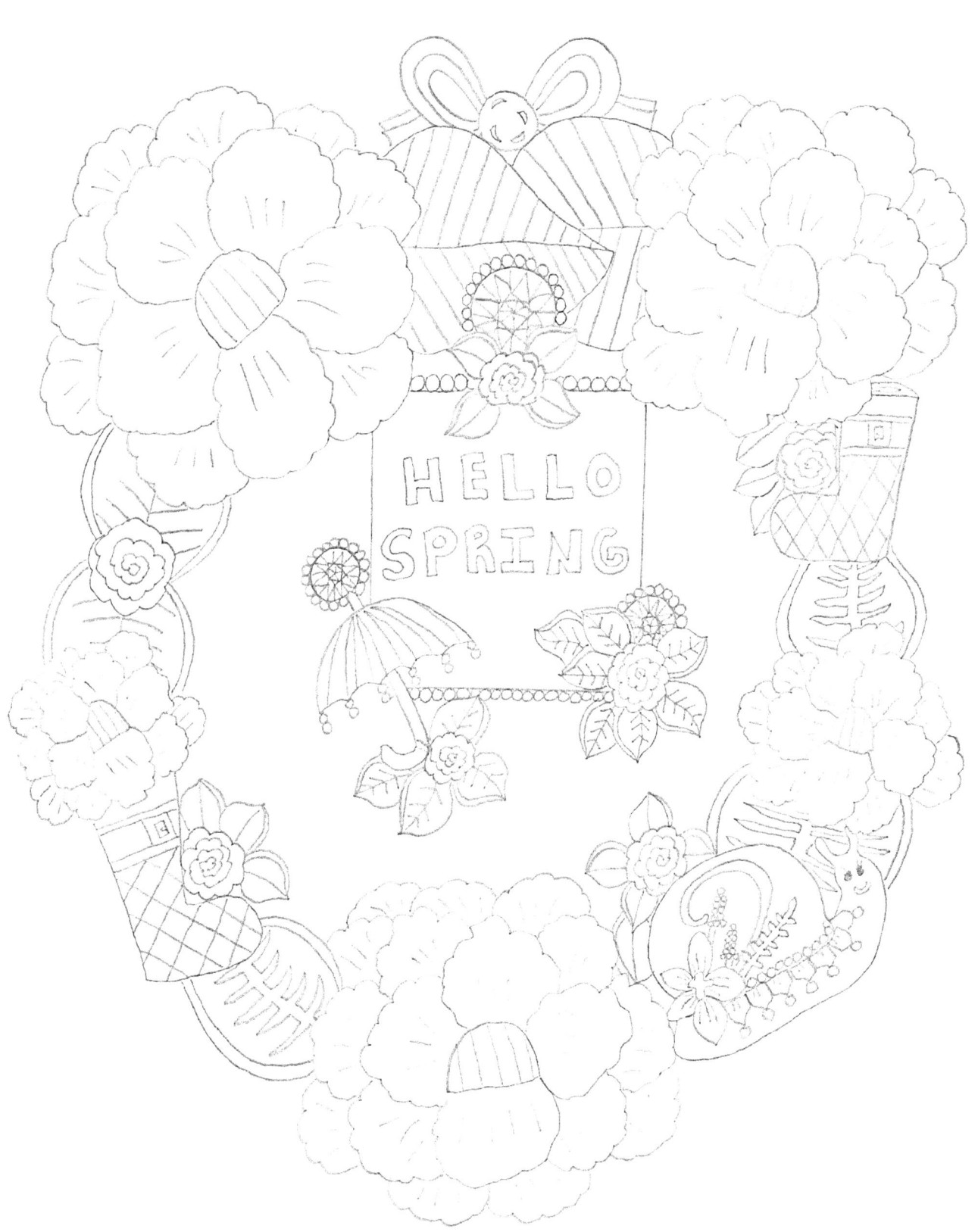

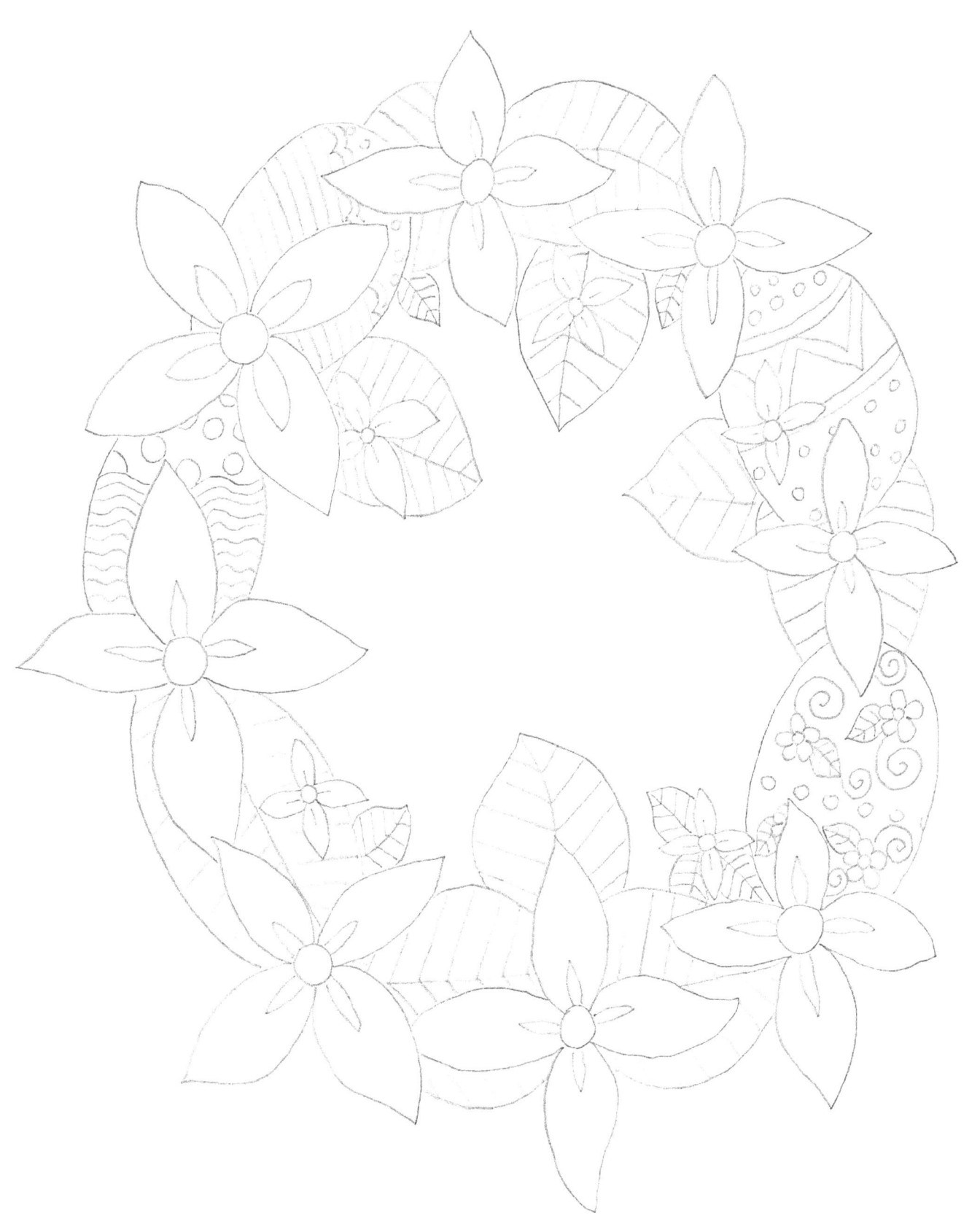

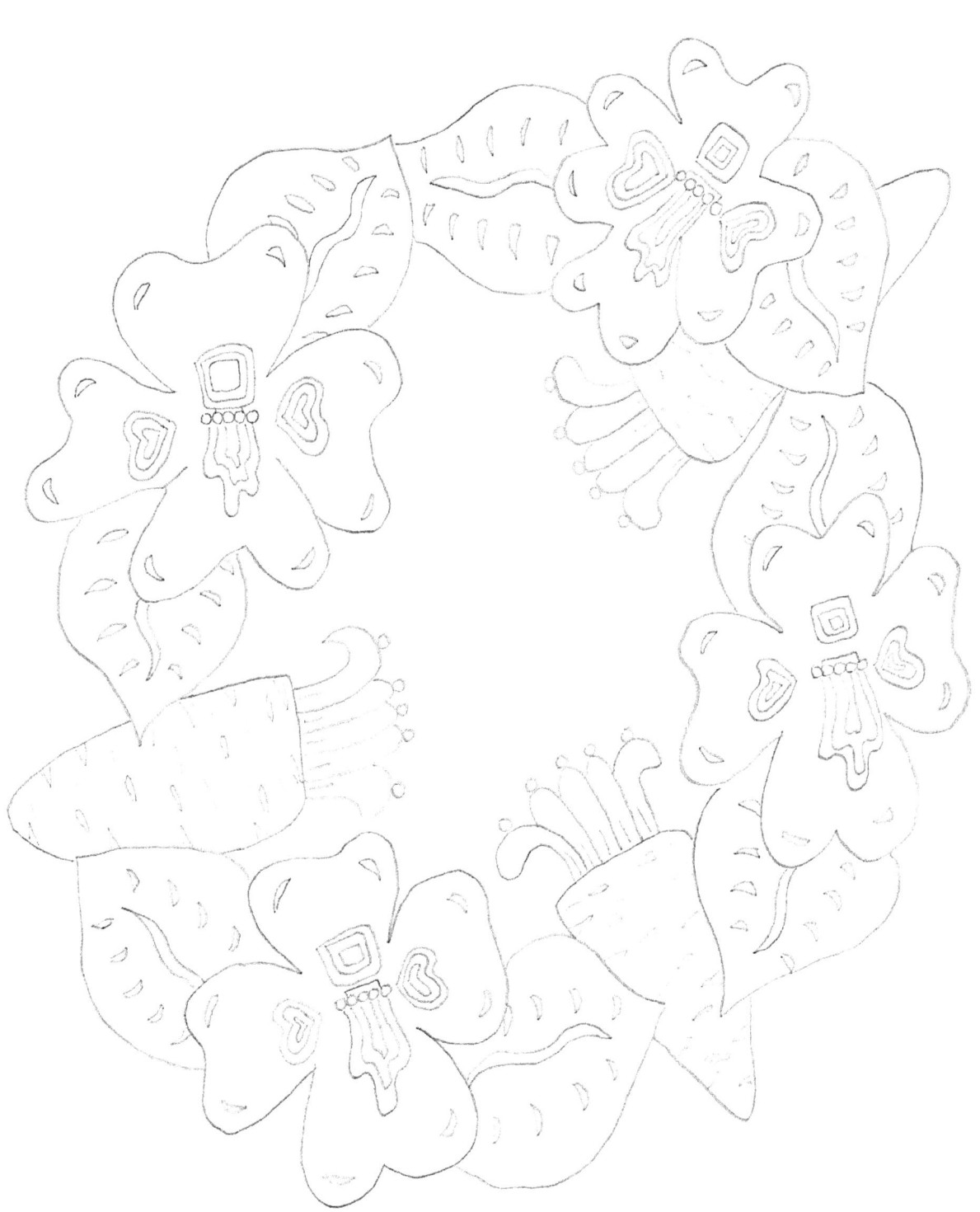

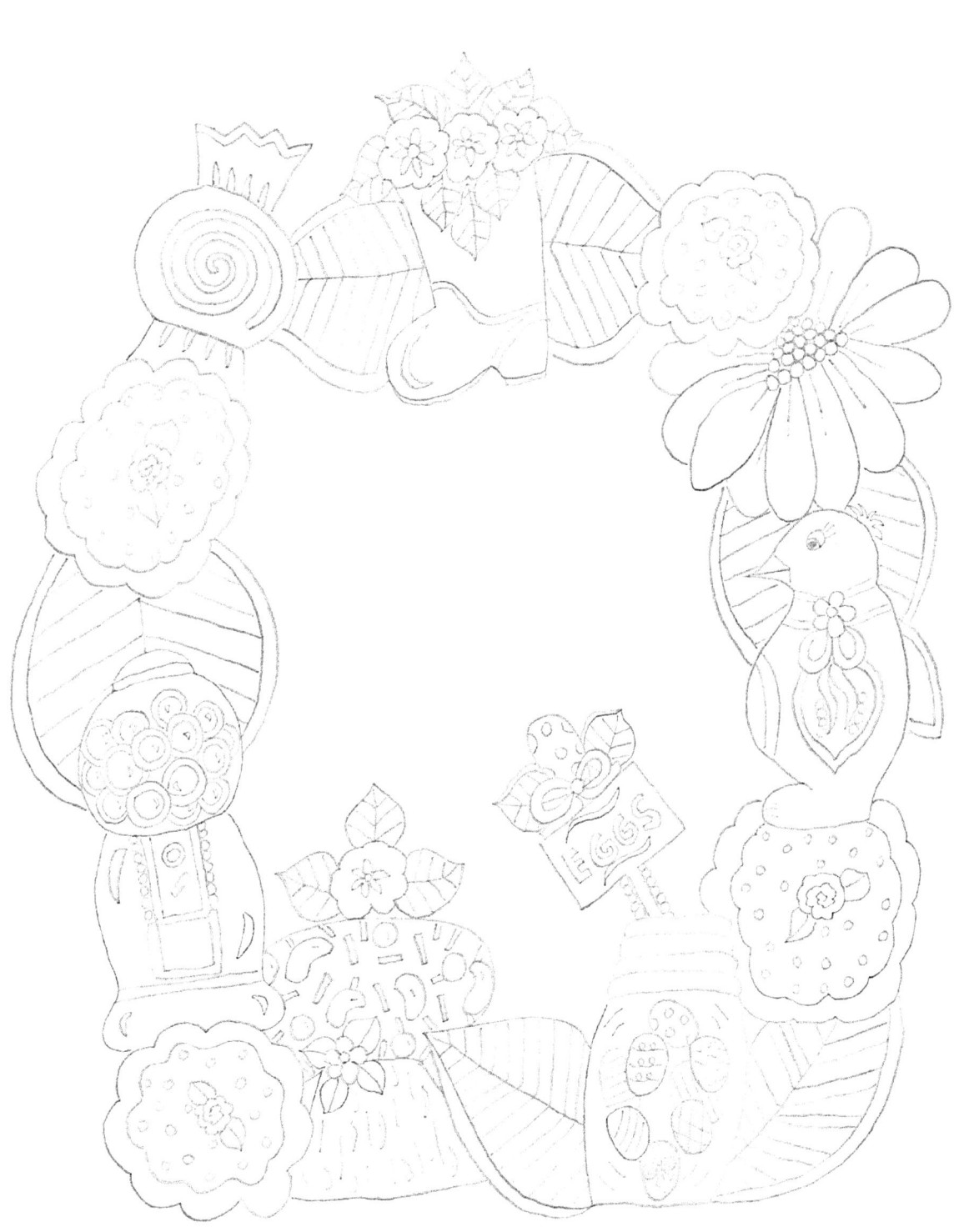

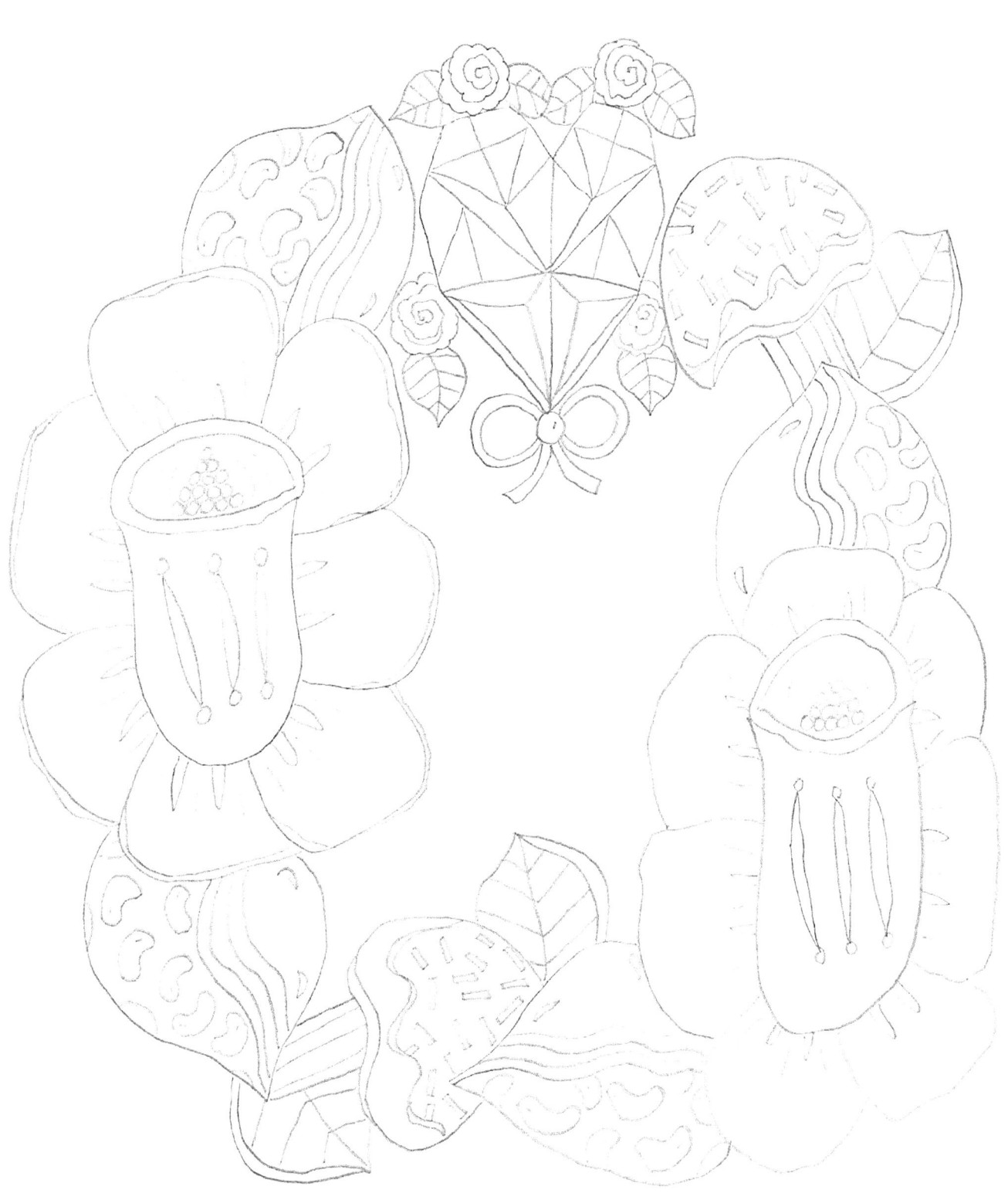

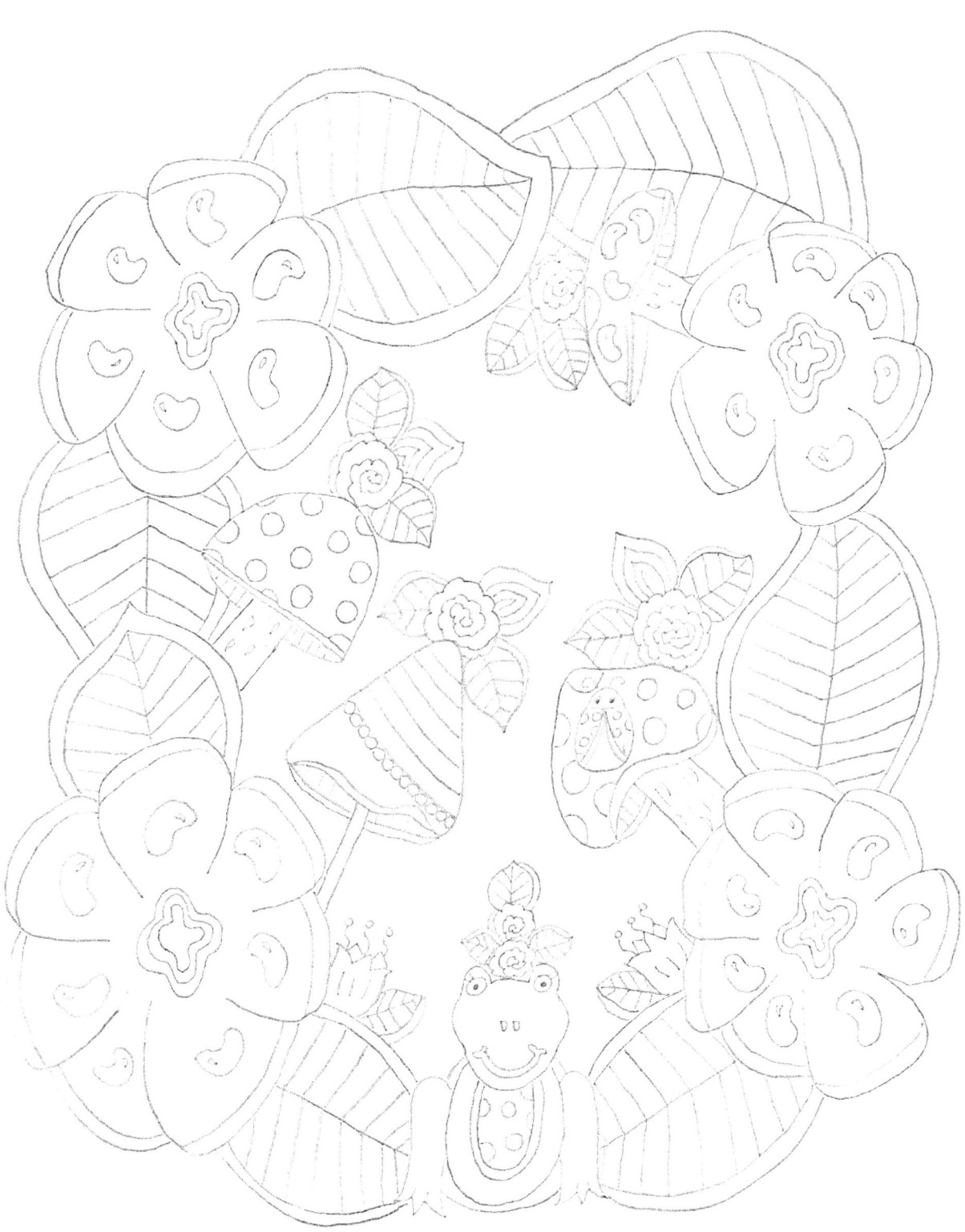

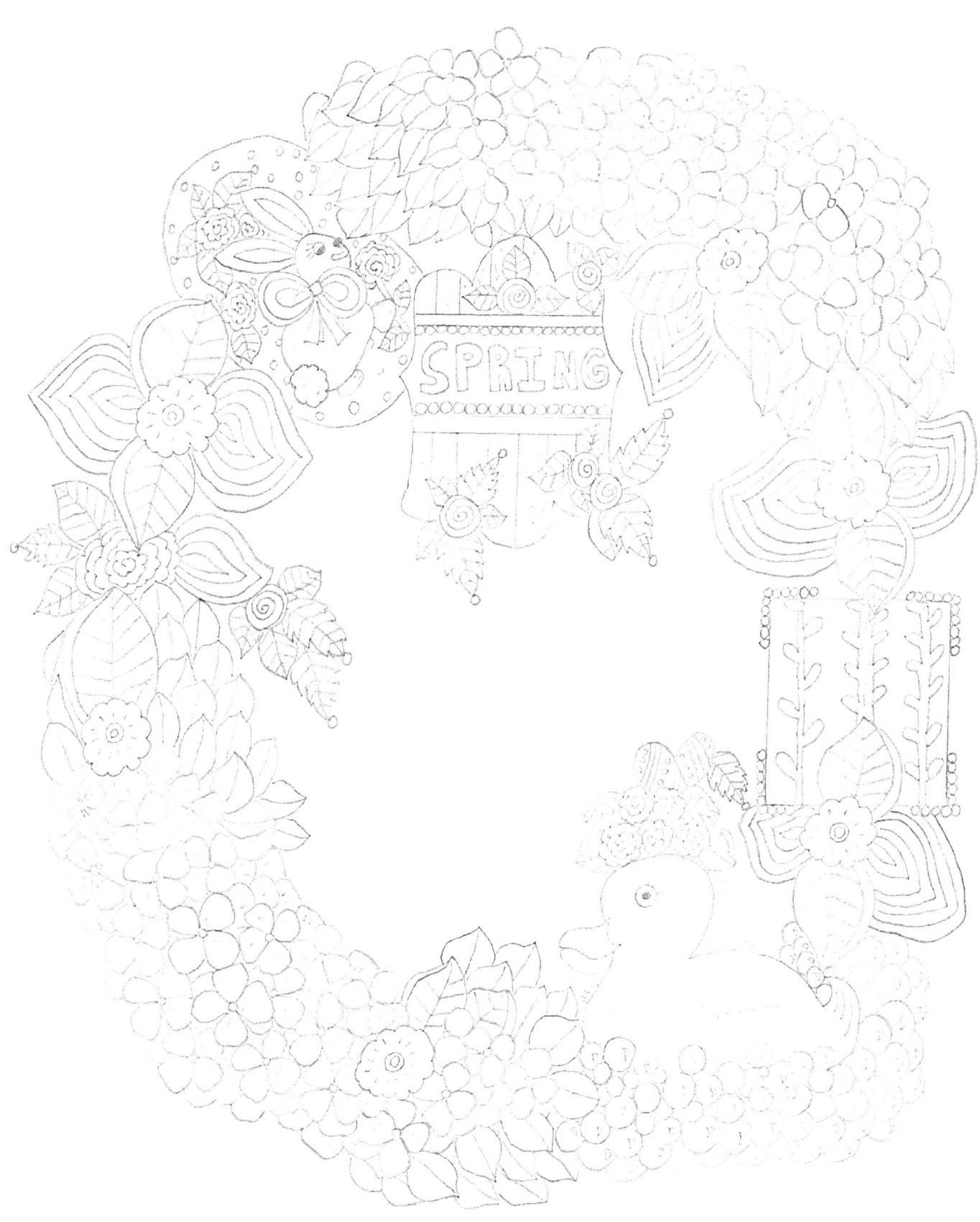

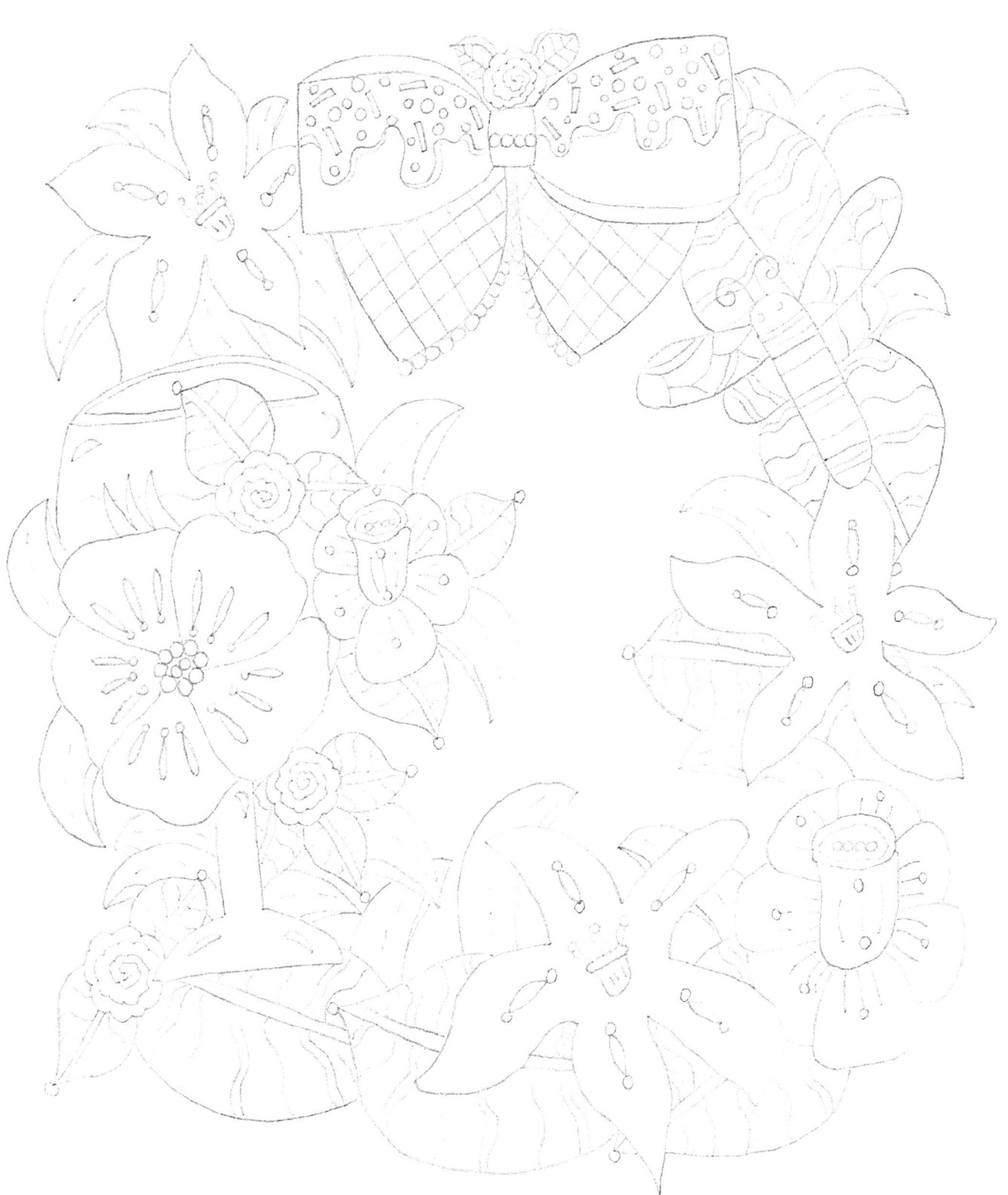

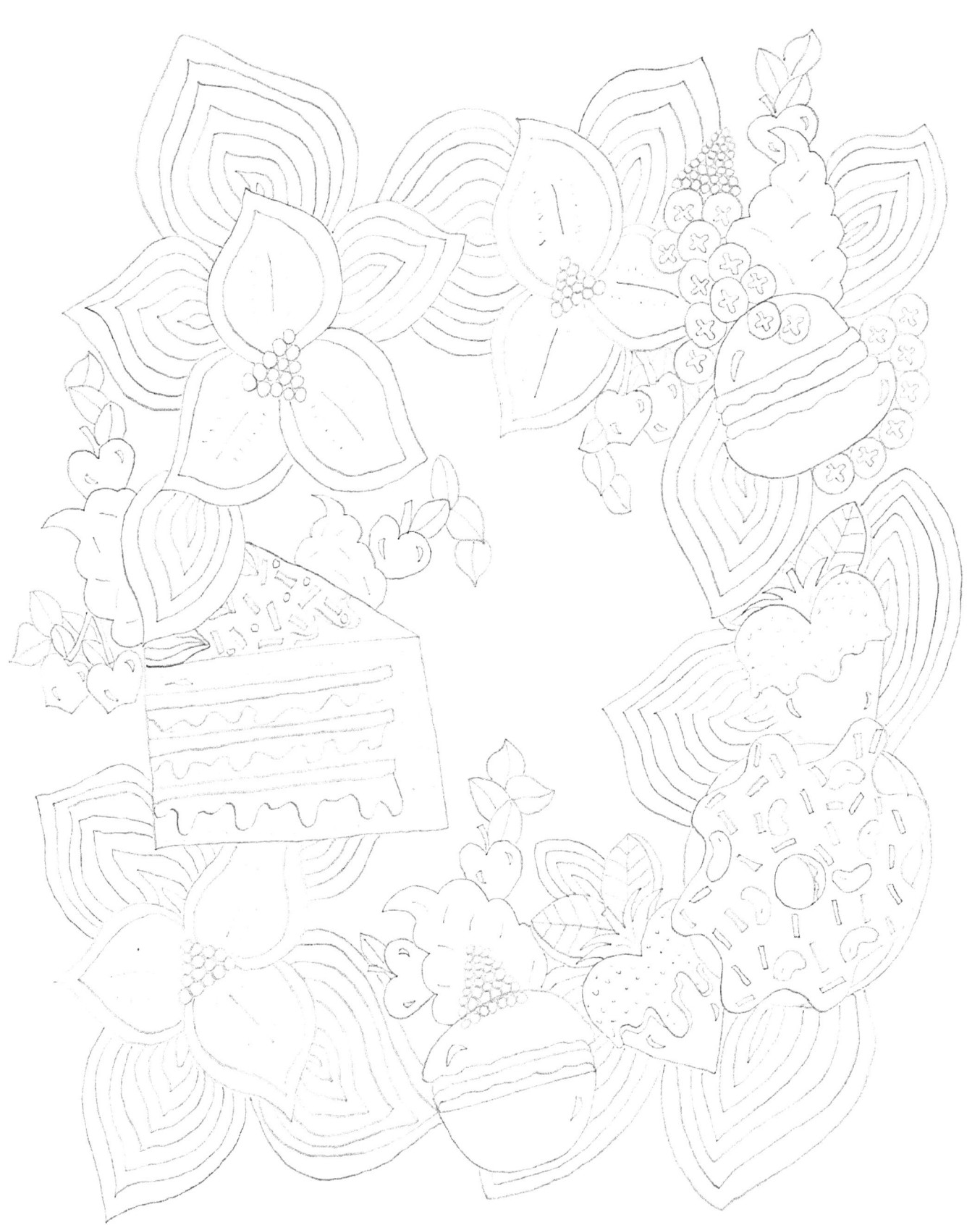

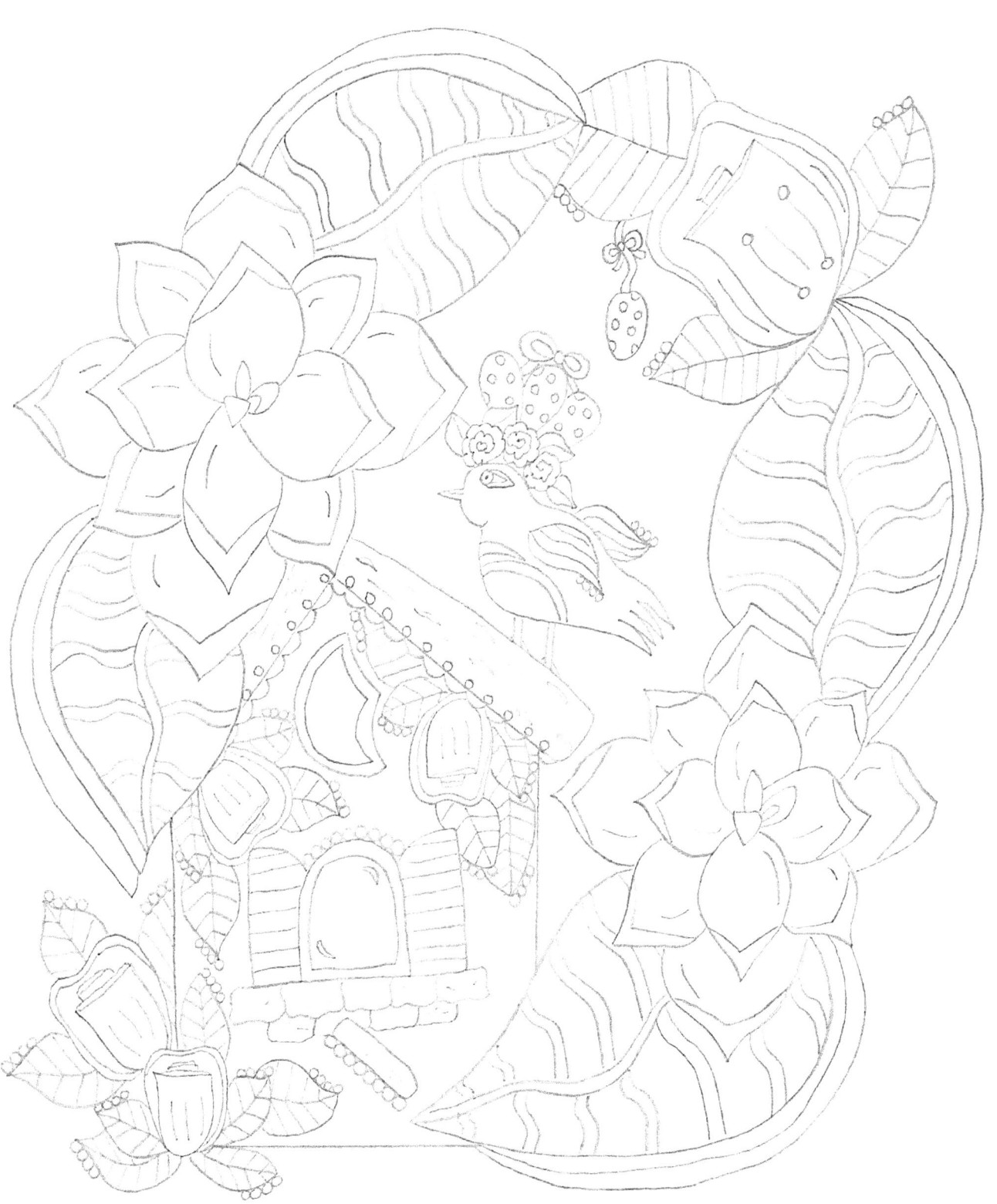

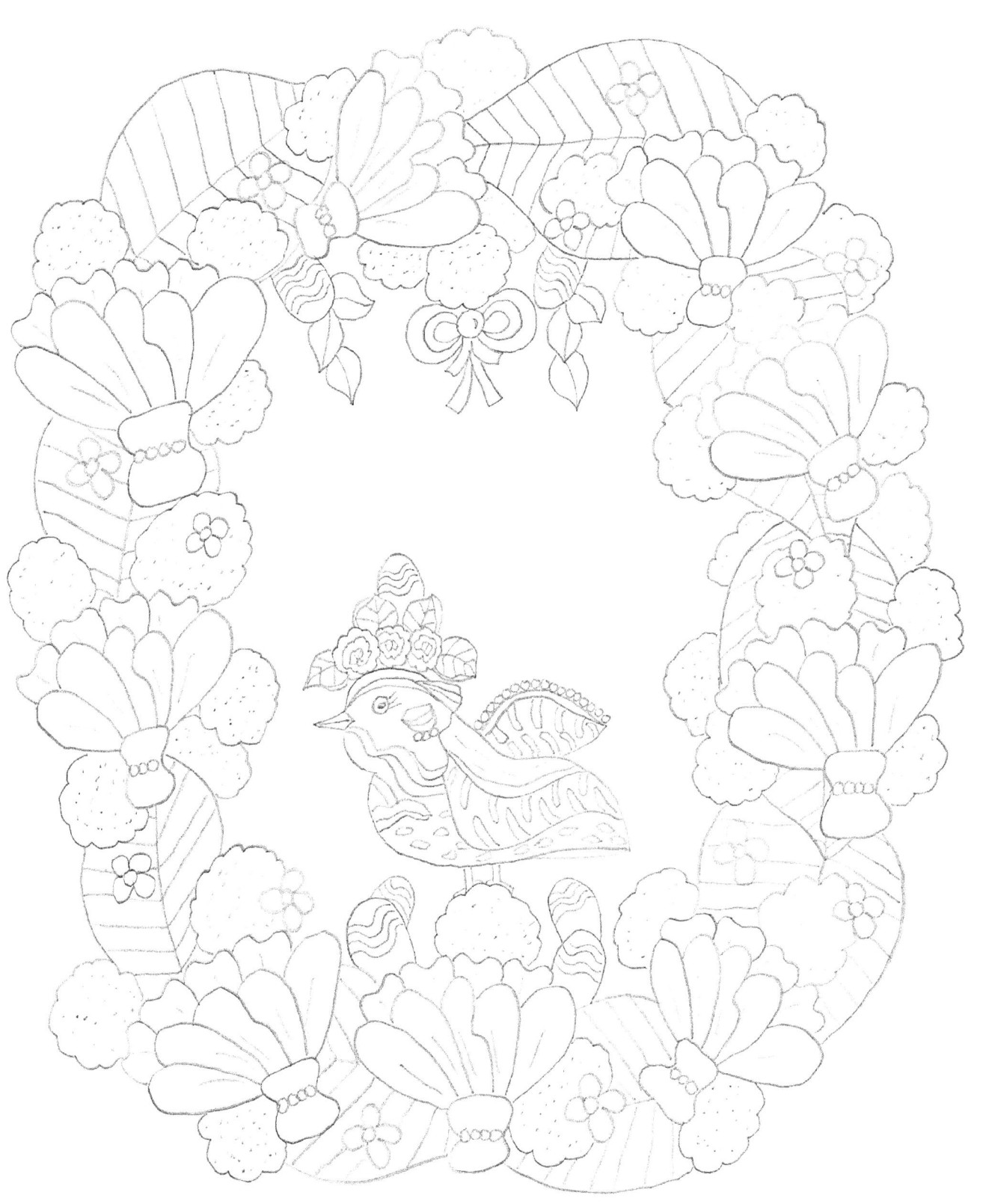

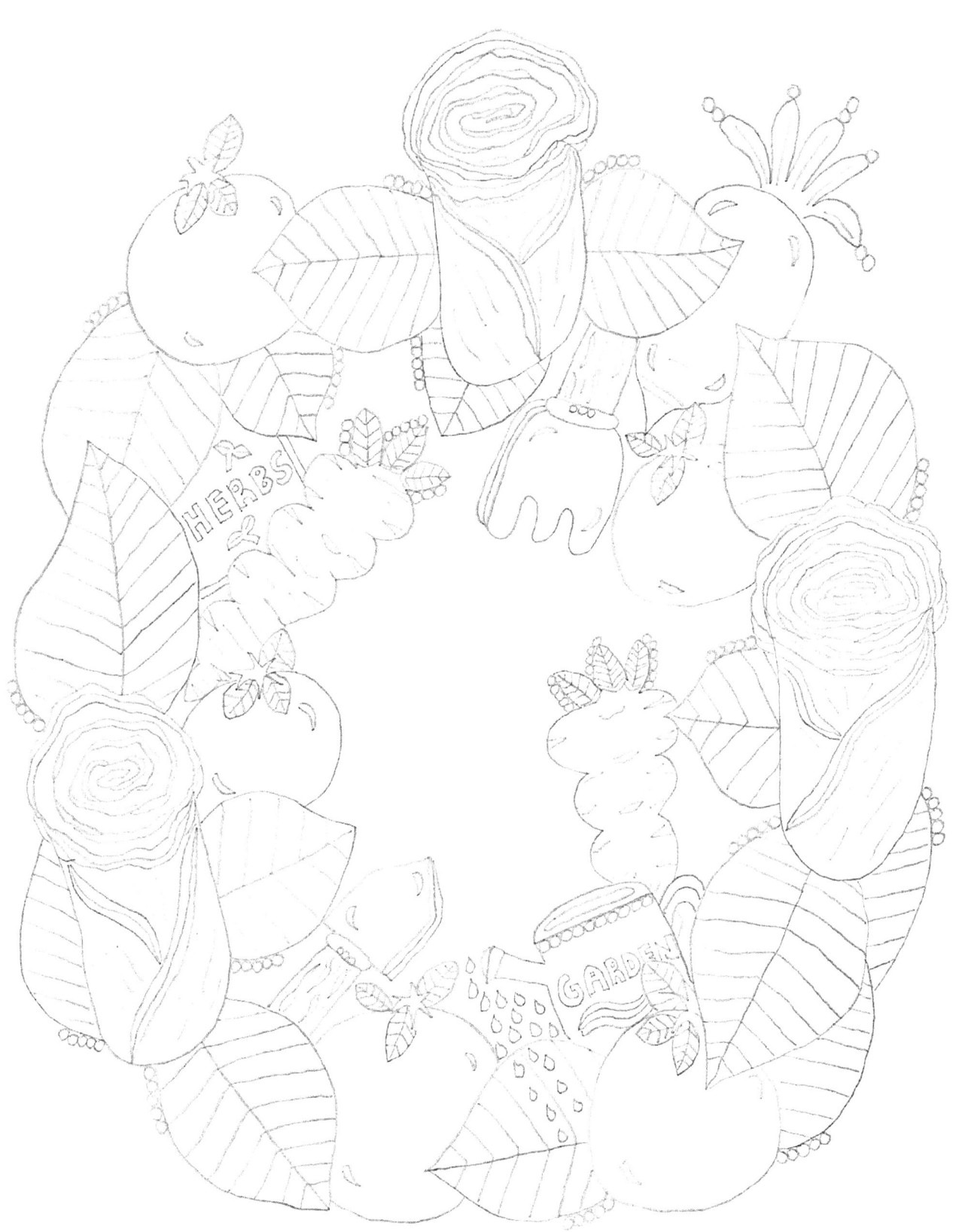

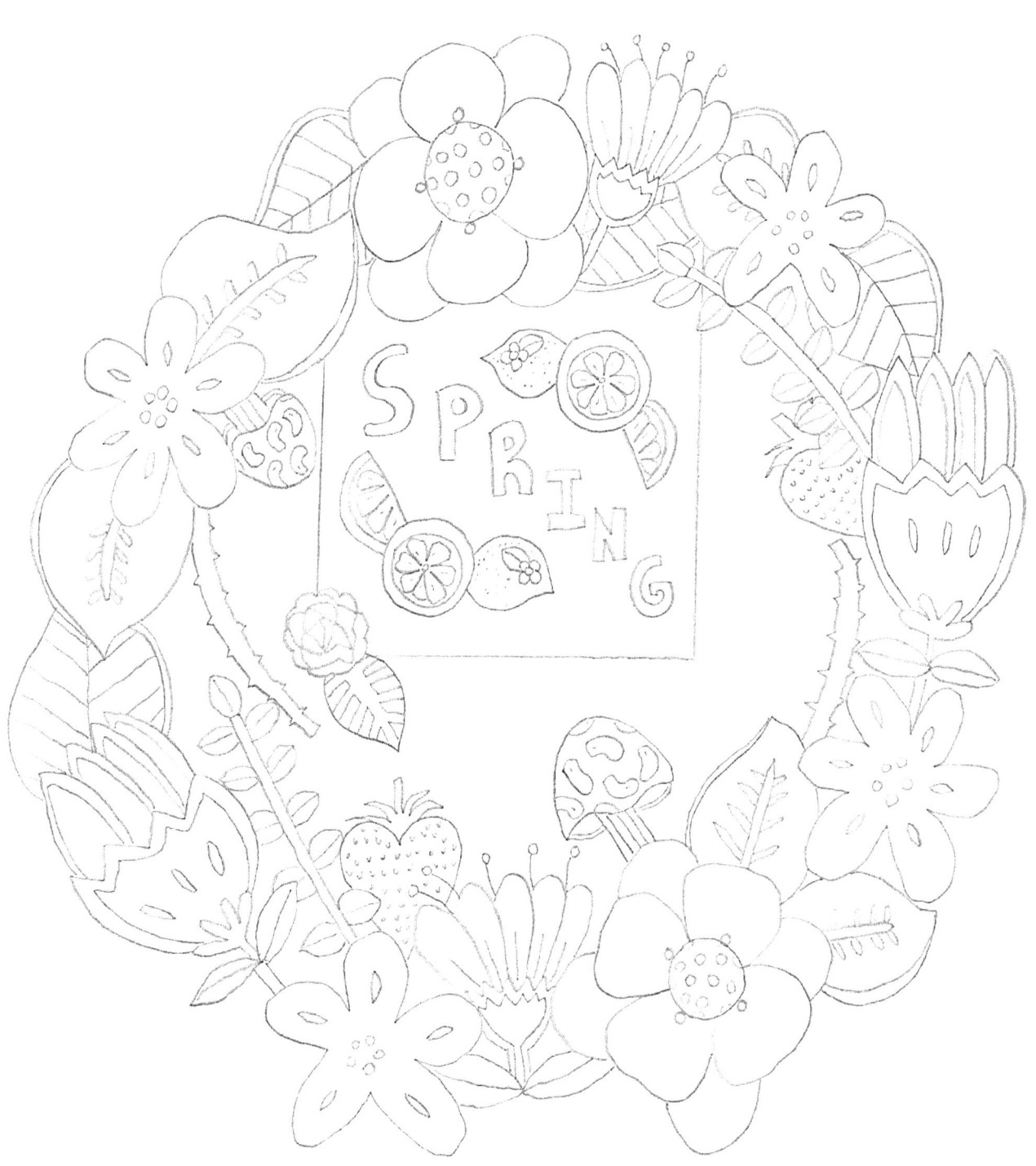

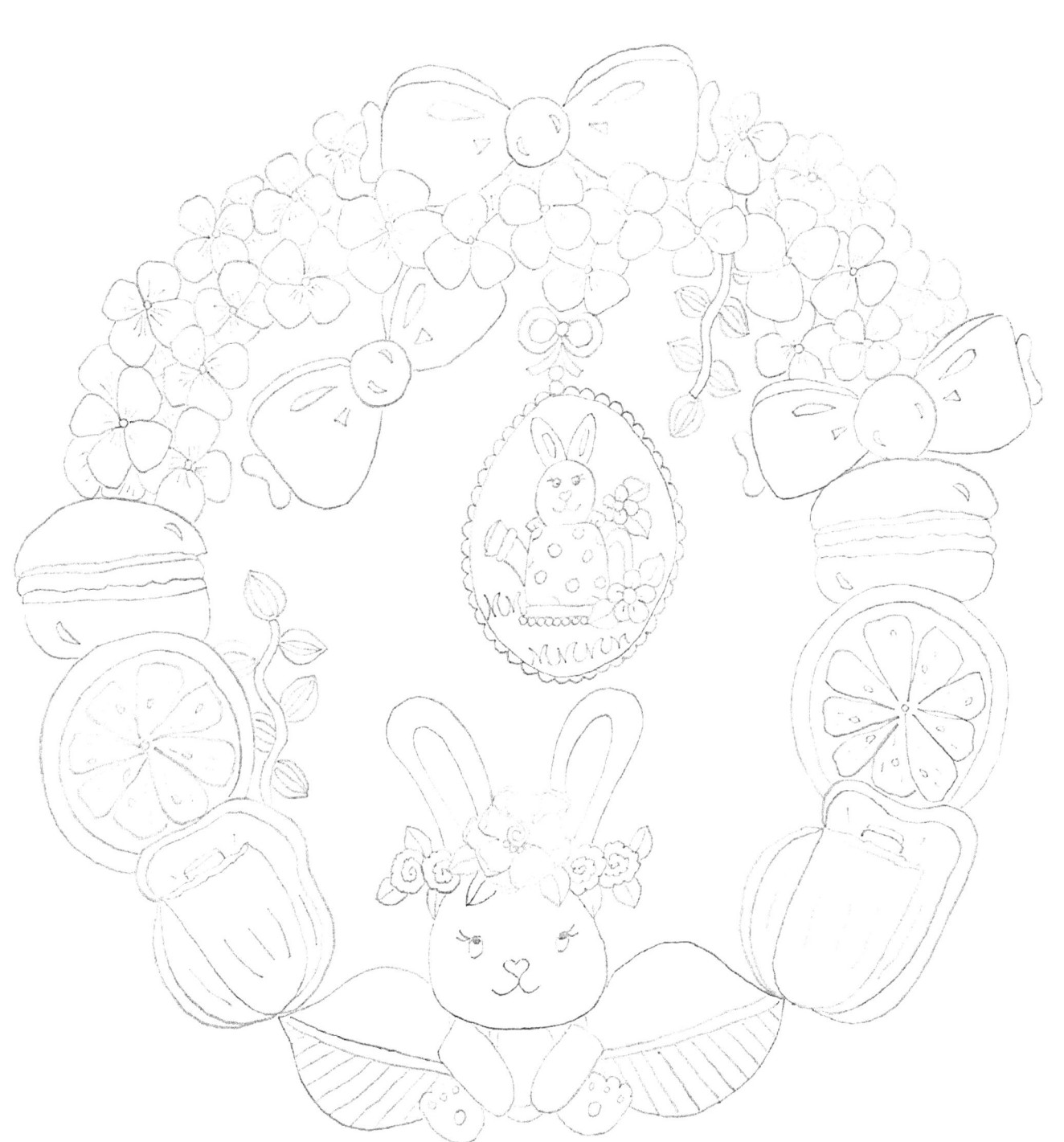

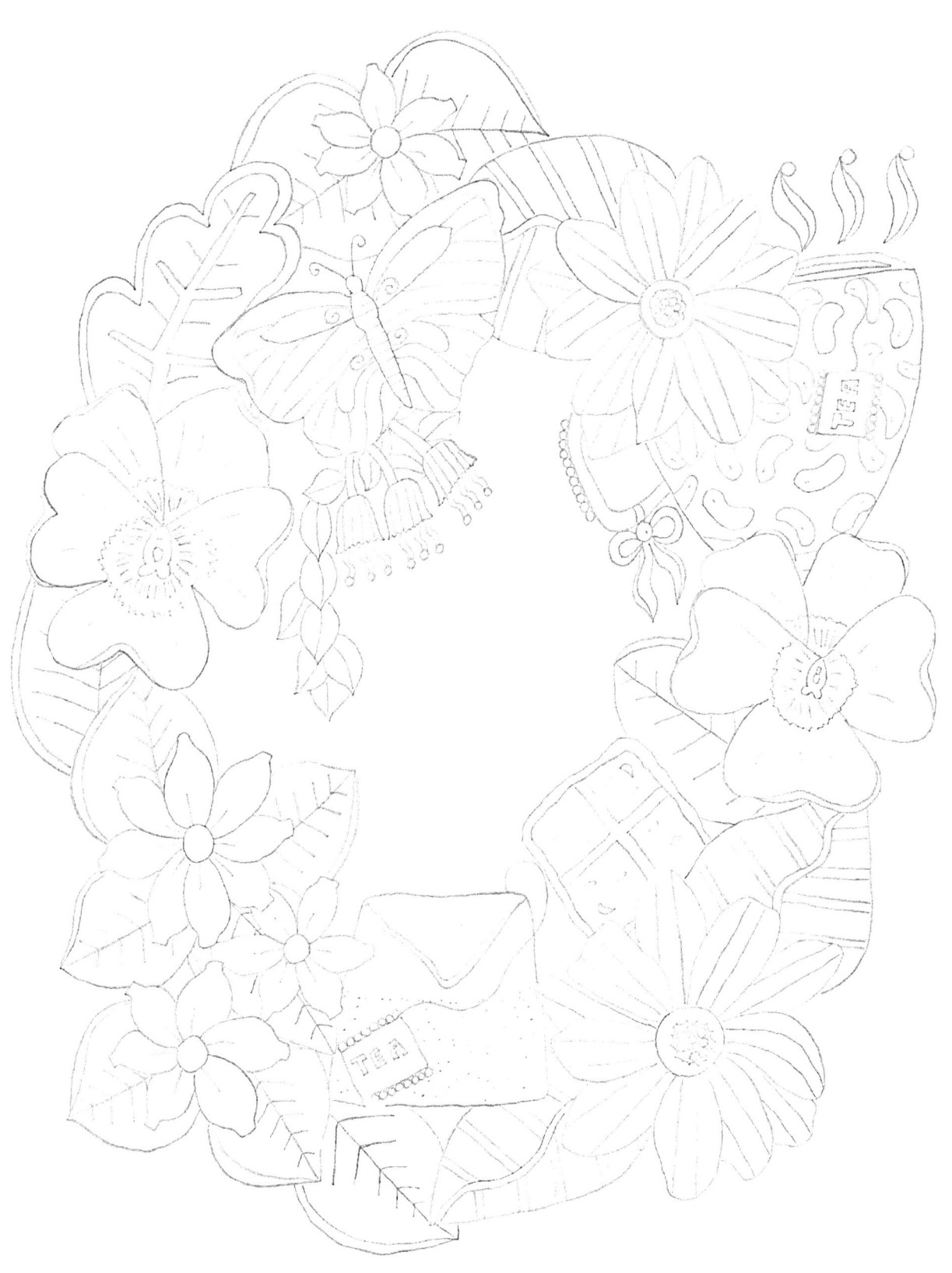

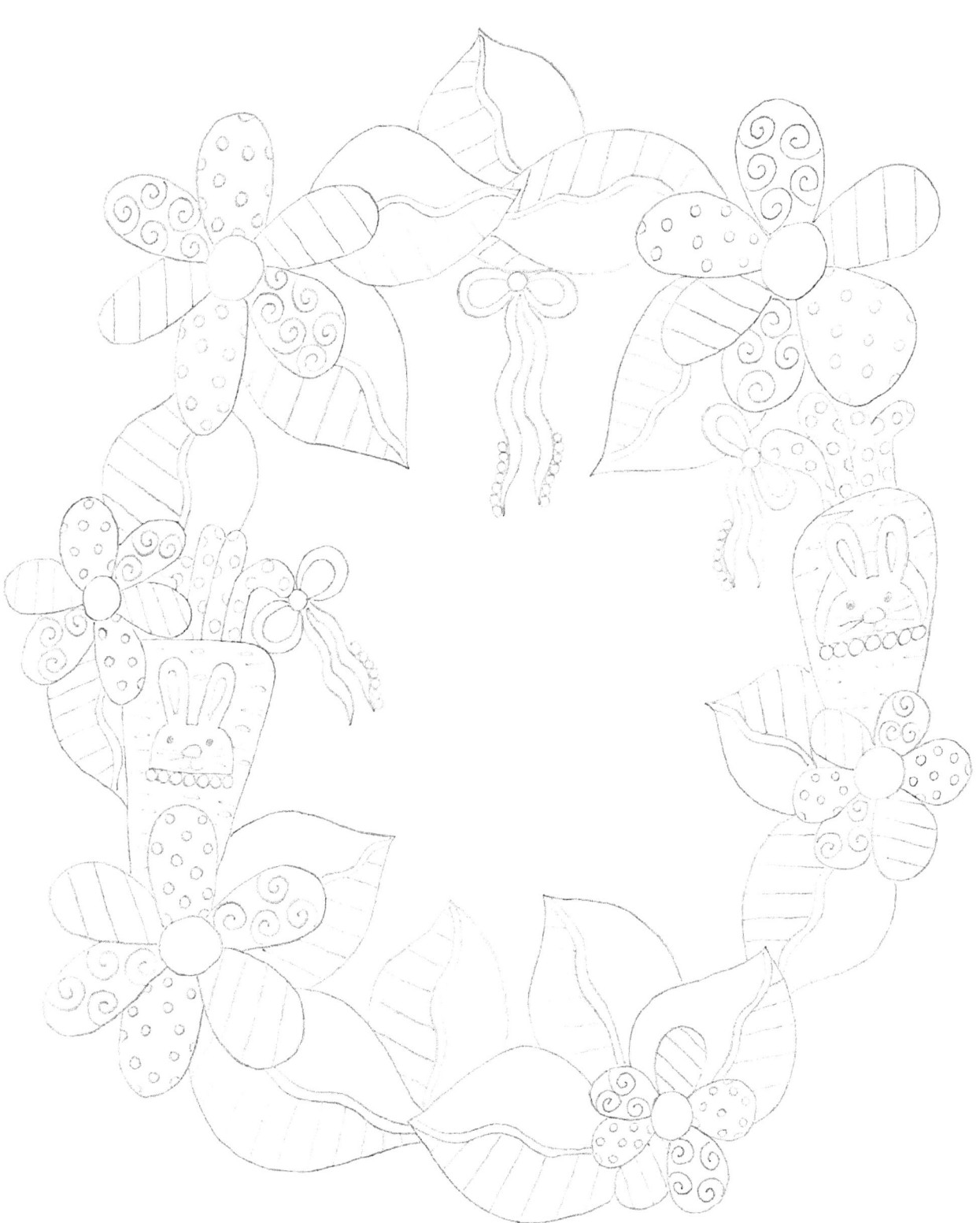

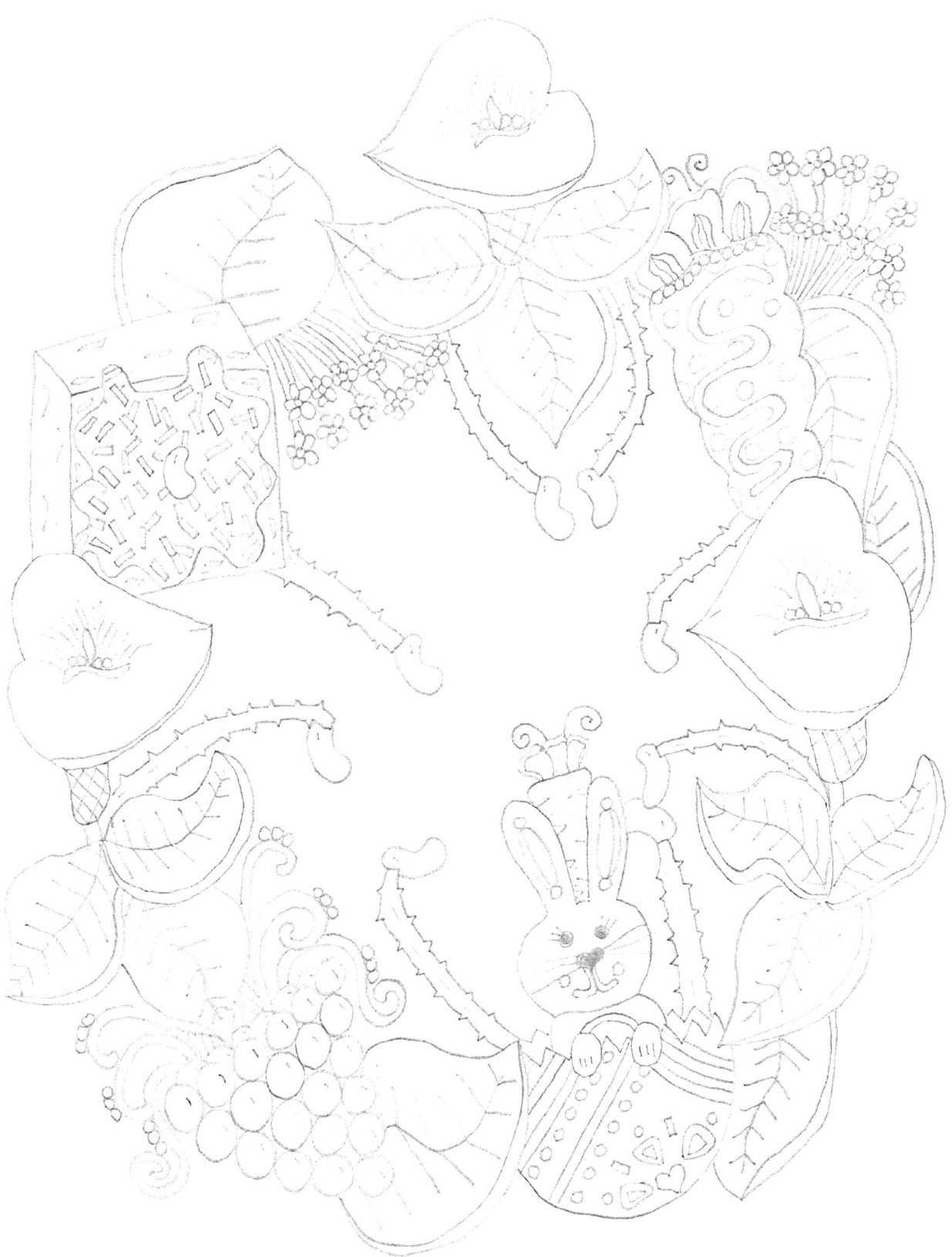

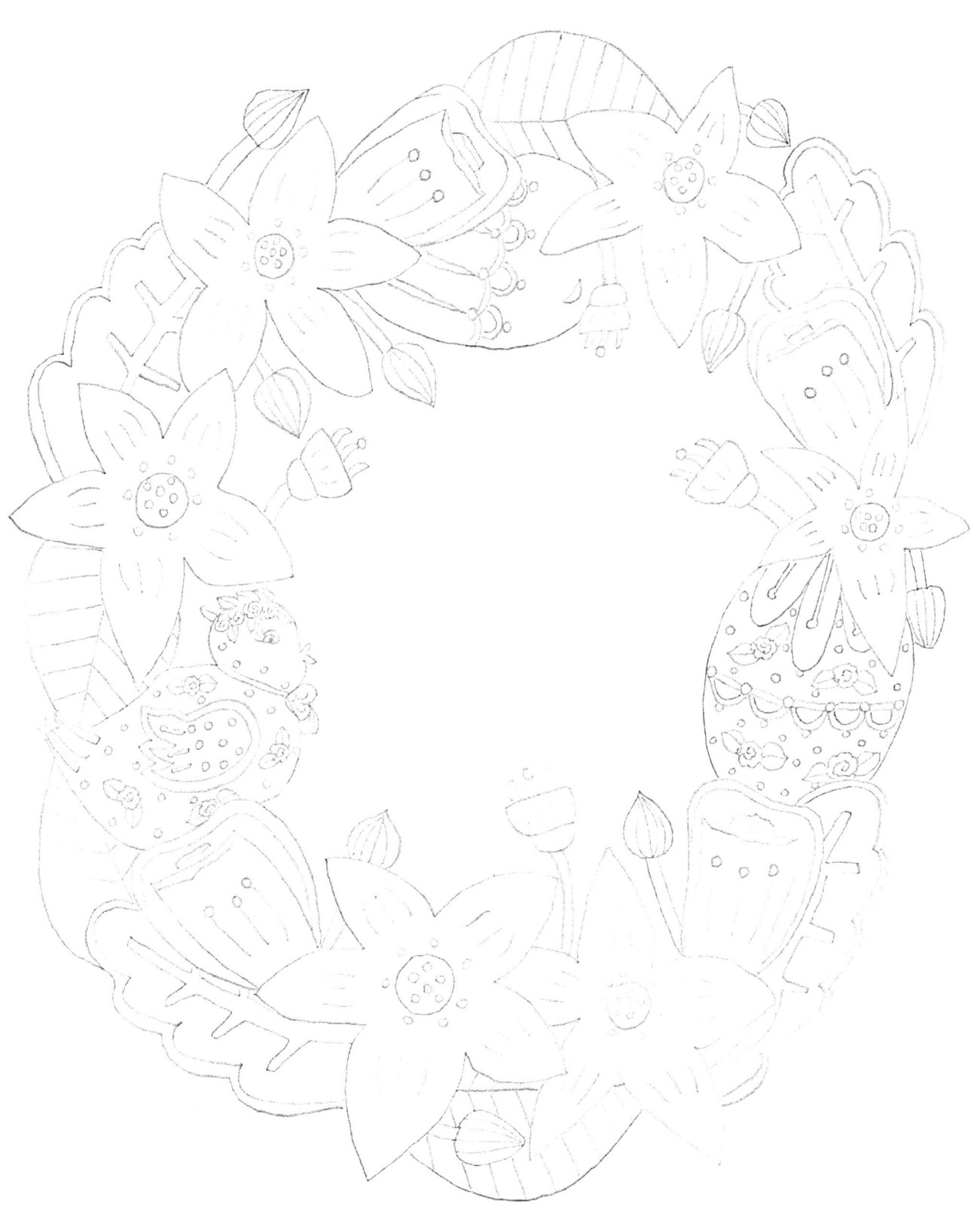

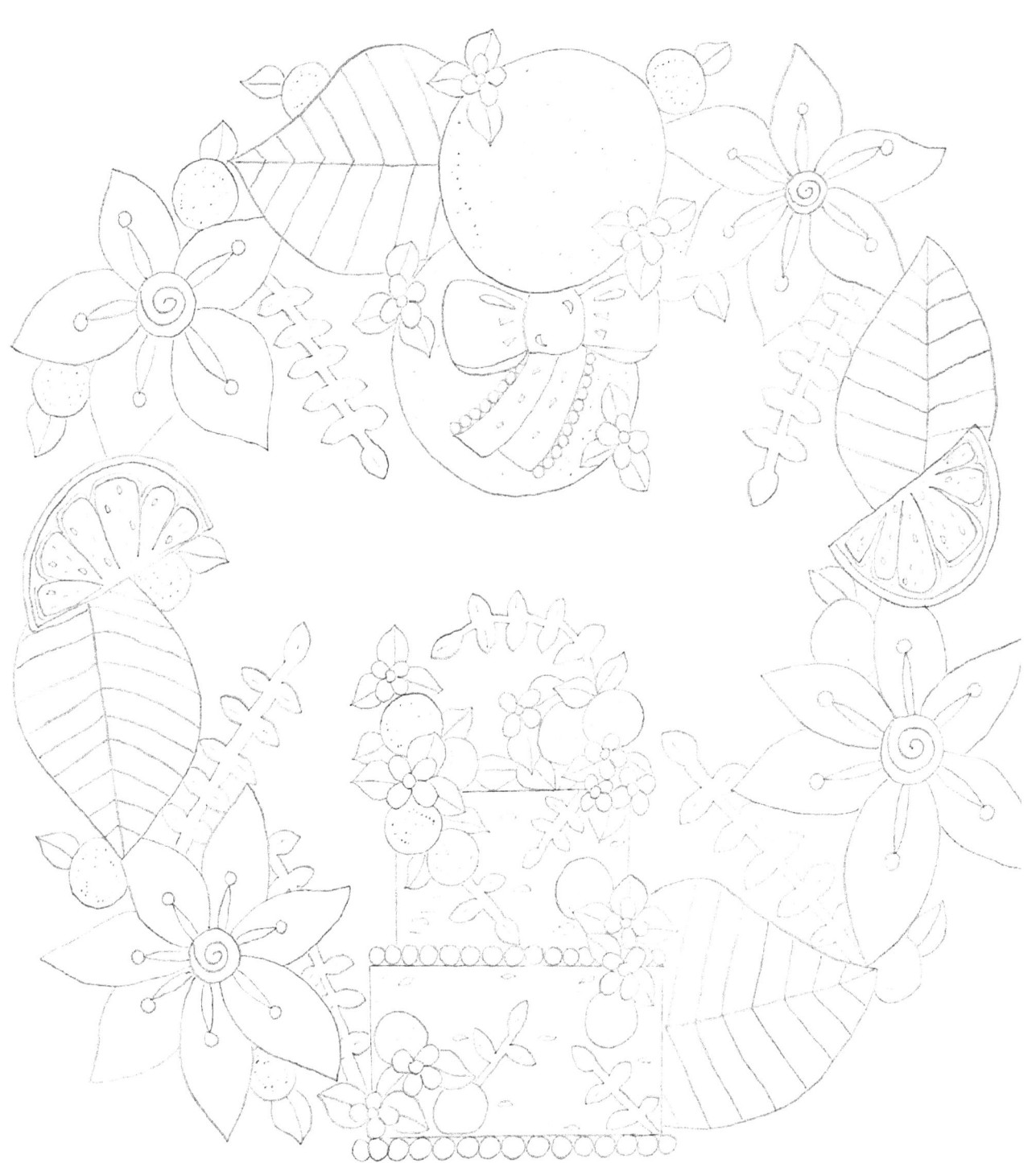

THANK YOU FOR PURCHASING FABULOUS SPRINGTIME WREATHS ADULT COLORING BOOK. YOU CAN CHECK OUT MY OTHER COLORING BOOKS LISTED BELOW WHICH CAN BE PURCHASED AT AMAZON.COM:

VINTAGE PARIS BAKE SHOP (Adult)
VINTAGE WINE GARDEN (Adult)
ICE CREAM MADNESS (Adult)
ICE CREAM MADNESS VOLUME 2 (Adult)
TEA & COFFEE TROPICAL TREASURES (Adult)
TEA & COFFEE OCEAN TREASURES (Adult)
TEA & COFFEE TREASURES (Adult)
BOTANICAL FLOWERS & MANDALAS (Adult)
MAJESTIC FALL (Adult)
A VERY RETRO CHRISTMAS (Adult)
MAGICAL DESSERTS (Kids)
MAGICAL DESSERTS VOLUME 2 (Kids)
MAGICAL DESSERTS VOLUME 3 (Kids)
FASHION DOLLS (Adult)
FAIRIES IN THE FLOWER GARDEN (Adult)
MERMAID'S WONDERLAND SEA OF ENCHANTMENT (Adult)
CHRISTMAS DESSERTS
VALENTINE'S DAYDREAMS COLORING BOOK (Adult)
VALENTINE'S DAY DELIGHTS (Adult)
VALENTINE'S FLOWERS & DESSERTS (Adult)
VALENTINE'S DAY DESSERTS (Adult)
VALENTINE'S DAY ANIMALS & Sweets (Kids)
VALENTINE DAY'S FLOWERS (Adult)
A VERY RUSTIC VALENTINE'S DAY (Adult)
ELEGANT FLOWERS (Adult)
ST. PATRICK'S DAY BLESSINGS (Adult)
A HAPPY ST. PATTY'S DAY (Kids)
ST. PATRICK'S DAY DESSERTS (Adult)
ST. PATRICK DAY FLOWERS (Adult)
SPRINGTIME FAIRIES (Adult)
SPECTACULAR DESSERTS (Adult)
BEAUTIFUL SPRINGTIME FLOWERS (Adult)
MERMAID DESSERTS (Adult)
FLORAL DELIGHTS (Adult)

IF YOU ENJOYED YOUR COLORING EXPERIENCE, PLEASE TELL OTHERS ABOUT IT BY WRITING A REVIEW ON AMAZON.COM UNDER THE BOOK YOU COLORED.

www.ingramcontent.com/pod-product-compliance
Lightning Source LLC
Chambersburg PA
CBHW080131240526
45468CB00009BA/2366